Ten Minutes to the Pitch

D0318784

Your last-minute guide and checklist for selling your story

by
Chris Abbott

The royalties from the sale of this book are being donated by the author to The Writers Guild Foundation for its Literacy Library programs.

Published by
Tallfellow® Press, Inc.
1180 S. Beverly Drive
Los Angeles, CA 90035
www.Tallfellow.com
ISBN: 1-931290-56-3
Printed in USA
10 9 8 7 6 5 4 3 2 1

Dedication

To Bubba and Mr. C., who make me laugh and who remind me that art isn't life, thank God.

Acknowledgements

As is true of any endeavor, there are countless people to thank:

Patricia Cummings at the Writers Guild Foundation and the Tall Fellow himself, Leonard Stern, for bringing this project to me and shepherding it through the briar patches.

The rest of the Tallfellow Company—Larry Sloan, Bob Lovka, Laura Stern, Claudia Sloan for patience, good humor, editorial assistance and other random acts of kindness.

Chris Barrett, Bob Myman and Beverly Magid for uncommonly clear-sighted advice, untiring work and friendship.

The talented and generous writers whose words of wisdom and encouragement appear in the following pages: Carl Binder, Steve Brown, Allan Burns, Terry Curtis Fox, Dean Hargrove, Charlie Hauck, Barry Kemp, Dylan Neal, Daryl Nickins, Burt Prelutsky, David Rintels, Becky Southwell, Joel Steiger, Jeri Taylor, Eric Tuchman.

Extraordinary friends and fellow writers whose stories, whether specifically recounted in these pages or not, have inspired and amused me for more years than I will admit to: Nancy Griffith, Janet Paist, Lauren Levian, Yvonne Prelutsky, Victor Lobl, Beth Grant, Glenda Nelson, Vicki Nelson, Jennifer Tait, Robin Russell, Melody Fox, Janine Coughlin, Sean Ryerson, Manfred Guthe, Cathryn Michon, Lynn Latham, Bernard Lechowick, Bob Shayne, Walter Davis, Barney Rosenzweig, Philip Gerson, Cyrice Griffith-Siebens and Angela Kirgo.

My parents, Max and Twila Abbott, and my brother and sister, Steve Abbott and Becky VanHoak, my daughter and granddaughter, Michele and Isabella Mann, for giving me the best stories of my life.

And first and last, Darryl and Christian. 'Nuff said.'

Introduction

The Pitch—The Storytelling Part of Writing

Early in my writing career, an actress friend of mine said to me, "Are you going to push your story tomorrow?" I had never heard the term "pushing a story." I said something terribly smart and sophisticated like, "Huh?"

"Your story," she said. "Aren't you meeting with a big producer tomorrow to push it?"

"Oh!" I said, finally understanding, "Pitch. You mean pitching my story."

"Pitching?" she said.

"Yes. Pitching. Not pushing. Pitching."

"Oh," she said. I was pleased that I had cleared up that misunderstanding for her. After all, what are writers for if not to clarify and illuminate? I was proud of my grasp of industry terminology and happy to pass it along.

"Why do they call it 'pitching'?" she asked.
I had no idea.

Why *do* they call it a pitch? And while we're asking
pertinent questions, what the heck *is* a pitch, anyway?

We all know what writing is.

Writing is sitting alone in the dark with *IT* and it's
ITS turn.

Writing is pacing the floor, praying for inspiration,
procrastinating as long as humanly possible, and then, in
desperation, taking Mary Heaton Vorse's admonition—
"The art of writing is the art of applying the seat of the
pants to the seat of the chair"—and turning out page
after page of moldy straw which somehow, by the time
you're finished, has turned into gold.

That's writing: mind-numbing, lower-backbreaking,
soul-twisting hard work. But what is pitching?

Pitching, it turns out, has little or nothing to do with
writing. What it has everything to do with is selling.
Pitching is the initiation rite you have to endure
before being allowed the honor of writing (and
getting paid for it!)

There may be some long-forgotten reason this

torturous ritual is called pitching. If there is, I've never heard it. It seems to me that this process of trying to sell a story is called pitching because of its obvious similarities to baseball.

You stand alone on the mound, facing the enemy, sweat pouring into your eyes, holding in your hand the one thing that can get you a deal: your best curveball idea. Your heart pounds, you concentrate only on that miniscule area identified as the strike zone where you have to place your idea or face being taken out of the game. You know that you only get one shot. One chance to put your great, big, tremendous, fabulous idea through that tiny, microscopic little window of opportunity. And by the way, everything you say and do during the pitch counts.

You wind up, you throw your best idea at them with every skill you've ever learned, with all the hope you've ever held in your heart, and then you sit back and wait. Because now it's out of your hands.

My friend Jeri Taylor (*Star Trek: Voyager*) once told me that there's no such thing as a good pitch that doesn't sell. What difference does it make how brilliant you are if you don't walk out of that room with a sale? She's right. No question about it. But I didn't always think so.

When I first started writing, I had a slightly distorted image of the writer's life. I thought that writers spent most of their time sitting around the pool, working on their tan, throwing out bon mots to their writer friends until lunchtime and then went down to the Polo Lounge to see and be seen. Or, if they were a little down on their luck, they'd go to the Hamburger Hamlet for a burger and a beer. They wore blue jeans and athletic shoes and white linen shirts. Every Friday night they went to The Mucky Duck in Santa Monica for ale and darts and, most importantly, they always looked like they'd just had incredible sex.

I never envisioned any of them working fourteen-hour days, seven-day weeks, scrambling their brains to figure out how to fix a script so that the star, the studio, the line producer and maybe even they themselves were happy with it. I never envisioned any writer going years without a day off because if a show is going to have any scripts when the crew and the actors return from their month-long hiatus in Bermuda or the south of France, then the writer must stay in town during the hottest, smoggiest time of the year to churn out material for the network to reject.

No. I envisioned writers at Hollywood Park placing two-dollar bets on the Exacta and amusing their friends with clever ideas for movies that no one would ever make.

My idea of the perfect pitch would have gone something like this: there's a "drive on" pass waiting for you at the gate. You park in a reserved space and jog up the stairs to the Office of the President. He's waiting for you. He tells his secretary to hold all calls. She does. You amuse him with small talk and then ever so modestly mention your little idea.

The President of the studio loves your idea. It's the best idea he's ever heard. In fact, he loves your idea so much that he now loves you. He'd kill to make your inventive, charming yet blindingly commercial idea into a major motion picture, but unfortunately, he's already bought an idea just like it. Not identical to it. No, in fact, he likes your idea better than the one he just bought. But what can he do? He's already committed funds to some other inferior writer who's going to turn in an inferior product and, as heartbroken as he is about the situation, there is absolutely nothing he can do about it. Maybe you can do business together another time.

Now that, in my opinion, is the perfect pitch. They loved you, you don't have to actually sit down and write, and you still have time to make the third race at Hollywood Park.

I even tried to start my own version of the Algonquin Round Table, thinking that without argument the

most enjoyable thing about being a writer is hanging out with your urbane friends making caustic remarks that will be studied in Graduate School programs for decades. Unfortunately, it never worked out. I think it was because there is not a single bar in Los Angeles with the ambiance of the Algonquin. It can't have been lack of wit on our part or lack of drinking, either, for that matter.

If your idea of writing bears the slightest resemblance to mine, you don't need to read this book. In fact, you really don't *want* to read this book. This book will give you the tools you need to sell your ideas, and then you're going to be working day and night for 20 years and never get a day off again which will seriously interfere with your social life! So please, do yourself a favor: put the book down and go back to your half-caf, soy, grande latte.

For the rest of you, I'm afraid the moment of truth has come. Do you want to be a "Writer"?

Or do you want to write?

If you're ready to become what you already say you are, turn the page. Your life is about to change.

"A writer is somebody for whom writing is more difficult than for other people."

—Thomas Mann

How to Use This Book

A Guide to the Contents

SECTION 1: *The Checklist*
You've decided you're a writer. You have an idea for a script. You even know how this script begins and ends. You're ready to grab Hollywood by the coattails and hang on for the ride of your life. Okay, nothing wrong with your intentions. But wouldn't it be a good idea to know what you're doing before you barge into some producer's office to convince him you have the next *Gone with the Wind* in your back pocket?

Do you even know that there are some unwritten rules about pitching your ideas to the people who can greenlight your project? You want to know what they are?

Here, in shorthand, are the 15 Do's and Don'ts to go over when there are literally "Ten Minutes to The Pitch." The checklist contains not only proven, practical pitching advice, but also, in some cases, a Zen way of looking at any aspect of your writing career, or of your life, for that matter.

Read through the checklist. Then read the rest of the book. Then, when there are ten minutes left before you walk into the pitch, go over the checklist again to make sure you've done everything you can to guarantee success.

SECTION 2: *The Details*
This section fleshes out the checklist; it is a more specific and detailed exploration of the checklist, with examples drawn from the careers of many successful film and television writers. Learn from their mistakes and from their triumphs.

SECTION 3: *The Marketplace*
How can you sell something if you don't know the marketplace? There is more to this than knowing which studio is buying action adventure stories this week. Know the people you're likely to meet, what they've done before, what they're likely to want to do next.

SECTION 4: *The Days (and Weeks) Before*
Don't show up the day of the pitch unprepared. All the checklists in the world won't save you from disaster under those circumstances. This section gives you all the tools to prepare and practice your pitch and to build your confidence. Included in this section are *The Three Knows: Know the Industry; Know Your Story; Know Yourself.* The at-a-glance resource and

reference guide will be invaluable to you.

Read the book once, twice or three times if you like. Practice everything it tells you to do. Then, the next time you have an important pitch meeting, take the book with you and go over the guidelines in the parking lot. You'll knock them dead. Unfortunately, you'll also get the job and have to go home and write. Don't say I didn't warn you.

Final Note: Yes, it's important to have an agent. I know, everyone has already told you that. What they haven't told you is that until you have an agent, you can do a lot of footwork yourself. Write, write, write. Send your scripts to agents, producers, actors, production companies, managers. You'll find people who will read unrepresented material. And when people in the industry are talking about you, the agent will appear.

"I always do the first line well, but I have trouble with the others."

—Moliere

Checklist

1. Arrive Early

Allow yourself plenty of time to avoid flat tires and
momentary brain hiccups that leave you wandering all
over the county looking for the address you thought
was a cinch to find. Can't remember the other
reasons you wanted to arrive early?

2. Are You Where You Want to Be?

You wrote down the address, you've used your
handheld Global Positioning System... how could
you possibly be in the wrong place? It happens. This
guideline will tell you how to be where you want to
be in more ways than one. Remind yourself what
those ways are

3. Bring a Pencil, Notebook and Your Idea with You

A note to the overly confident: It's a good plan to
actually *have* an idea before you make an appointment
to pitch it. Remember

4. Go to the Restroom

It's a great place to calm down, go over your notes

and make sure you don't have spinach in your teeth.
You never know when you'll get another chance. If
you can't remember why this is a good idea, read
the details . Page 41

5. Be Pleasant to the Assistants

Today's receptionists are tomorrow's studio heads
and they'll remember exactly how you treated them
way back then. This is your opportunity to make that
memory a happy one. You haven't forgotten the
many paths to successPage 45

6. Don't Forget to Breathe

Breathing helps you stay composed and calm. It
also helps you stay alive. This is too important
to skip .Page 49

7. Know the People in the Room

Know their names, know their successes, know
something about their lives away from the studio.
If you want your pitch to be successful, know the
differences between pitching to a producer, an actor,
a director or a writer. Everything depends on your
knowing who they arePage 53

8. Turn off Everything but Your Mind

Abbott's First Law of the Unpredictable Universe: the
minute you've captivated the studio executive, your
phone will ring. Turn it off before you enter the office.

9. Don't Start Pitching Until You're in the Room

10. Tell the Story You've Come to Tell

11. Expect the Unexpected

12. Be Memorable

13. Don't Leave Before You're Finished
Why would anyone leave before they've finished?
It's possible you're doing it without even realizing it.
Better know for sure. RereadPage 93

14. Make a Graceful Exit
The way you leave may determine when—or if—
you'll be asked back. You want to be asked back,
trust me .Page 97

15. Have Someplace to Go After the Meeting
It's the only way you can retain your sanity in a crazy-
making industry. And contrary to popular mythology,
you don't have to be crazy to be creative. Where
should you go after your meeting?Page 101

There you have it. Ten minutes; 15 rules. It doesn't get
any easier than that.

If you think you've already mastered these rules, you
might want to take a peek at the explanatory material
which follows. It's jam-packed with secrets and
surprises you'll want to know. Somebody in the room
is going to have the edge. It might as well be you!

"Success seems to be largely a matter of hanging on after others have let go."

—William Feather

1. Arrive Early

This concept seems self-evident, but based on my years of experience, it is not. I can't believe that anyone would *want* to arrive late. So my guess is that as a culture, we haven't yet learned why it's important to be on time... or even early.

Reasons you need to give yourself a few extra minutes when leaving for your pitch meeting:

- Even though you know exactly where you're going, it's still possible for you to get lost.

- You never know when there's going to be an accident or road construction that will add five hours to your travel time.

- You could get halfway there and realize you left your notes at home, or you've spilled coffee on your white shirt, or the heel on your shoe has come off or any number of disasters has occurred that necessitate an expenditure of time on your part.

- The assistant might have forgotten to leave your name at the gate. This could take half an hour to straighten out.

- You may have been sent to the wrong studio. How long will it take for you to clear up the confusion and then get across town to the correct studio?

All right, you know all the reasons it might take you awhile to get where you're going. But what's the big deal with arriving five or ten minutes late? Isn't it fashionable, especially in the entertainment industry, to make a late entrance? No.

Consequences of arriving late:

- The people you are going to see have moved on to someone else. Someone who knows how to arrive on time.

- The people you are going to see will sit and stare at you with thinly disguised irritation during your entire pitch.

- You are so distracted that you can't tell your story in an entertaining, coherent way.

- Your agent decides his/her time is better spent setting up meetings for clients who behave in a professional manner.

What makes me such an expert? I've been late a time or two in my career and it has never, ever been a good thing. There are always problems that will come

up to delay you. Don't let them. Just say "No" to procrastination. The price is too high.

If you take only one idea from this book, this is the most important one: when you arrive at a pitch— on time, with a fresh, inventive idea—you will be an unstoppable force. You will feel an energy and a confidence you hadn't imagined were possible. Give it a try.

"Scriptwriting is the toughest part of the whole racket... the least understood and the least noticed."

—Frank Capra

2. Are You Where You Want to Be?

I know what you're thinking: anyone with half a brain can write down an address, look at a map and show up at the right place. You'd think so. But it doesn't always work out that way.

A few years ago, I was working on a show that shot out of town. We came into Los Angeles periodically and during those times I would meet with writers and hear pitches. There was a young writer in whom I was very interested. I arranged the pitch meeting for early in the afternoon when everyone would be alert and fresh.

He didn't show up.

We started with the other writers who had arrived for their appointments on time. We saw one, then another, then a third. Still, the young man to whom I had hoped to give an assignment had not shown up. Finally we wrapped up and left.

As I was pulling out of the parking lot, I saw him

running frantically for the front door. By then it was too late and so I went on my way.

I discovered later that there was another building with almost an identical address a good ten miles across town. This young man had written down the correct address, hadn't noticed there was an east or a west, located the number on the map and driven there, giving himself plenty of time, only to discover he was at the right address
but the wrong place. Because there were fires burning out of control in the hills, traffic was impossible and it took him more than three hours to negotiate his way ten miles across town to the correct address. Simply mistaking East for West cost him an assignment.

How can you make sure this won't happen to you?

- Check, double-check, triple-check the address. Call the office the day before or the morning of your appointment to make sure you have the correct cross streets.

- If you've never been to this location before, make a dry run the day before your appointment. Try to make your dry run consistent with your appointment time so the traffic will be approximately the same.

- Print out a map from a map-and-direction service

Web site online. (If you don't have computer access, use a street map.) Outline the route with a highlighter pen so it's easy to read even when you're driving.

Despite your best efforts, you find yourself at the wrong address. What do you do now? There are a couple of ways to go.

- Call your agent (if you have one). He/She usually knows the person you're meeting with and can give you good advice about how to handle the situation; or

- Call the office of the person you're meeting. Let them know you've made a mistake and see if they want to reschedule or if it's convenient for you to come a little late.

- Don't let the misstep rattle you, but don't act cavalier about it either. Keeping people waiting is rude, and acting glib about it only makes it worse.

So physically, geographically, we're clear on making sure we're in the right place. Here's another angle on this concept: are you sure you're in the right place for *this particular idea?*

Every studio has a kind of signature. Some studios make blockbuster action films; some produce comedies; some are known for working with certain

stars. Early in my career, I took an idea for a light, romantic comedy to AIP. AIP is probably best known for *Attack of the Killer Tomatoes*. Not exactly the studio likely to produce a boy-meets-girl kind of movie. It was a waste of the producer's time and an uncomfortable 45 minutes for me.

Television has become the same way. Each network, mini-network or cable station has its own brand of programming. You shouldn't pitch a CBS show to HBO. Conversely, *The Sopranos* would never make the schedule at CBS.

It's imperative that you know the marketplace and that you do your research before you walk in the door. If a program executive listens politely to your pitch and then asks, "Where do you see this show fitting on our schedule?" and you don't know what their schedule even is, you're in a world of trouble. You should know more about their network than they do themselves. You're the one trying to get a job.

Once you've researched the marketplace, once you have a strong understanding of the studios and the people who run them, be aggressive in getting your ideas to the right people. You may have to run an obstacle course of people telling you that your idea isn't right for this studio or that director. If you have studied it and if you believe your instincts are right,

keep going after it even if you have to find a way to set up the appointment yourself. If you're not willing to go to any length to get your idea produced, it won't happen.

"Only a mediocre writer is always at his best."

—W. Somerset Maughan

3. Bring a Pencil, Notebook and Your Idea with You

Why do you need a pencil and a notebook? You've already done all the homework on your story. The pitch meeting is more of a performance, isn't it? Yes and no.

Here's why I take a pencil and a notebook with me: when I'm sitting in the lobby, waiting for the meeting to begin, my anxiety levels soar. Instead of biting my nails or jiggling my foot, I've taken to writing notes. These notes can be about almost anything: what I need to pick up at the grocery store, titles of books I've been meaning to read, ideas for other stories I might want to consider writing. On occasion, I've even made notes about the pitch I'm there to give. These aren't story notes; they're notes about whatever has happened to me that day or something I may have overheard about the executive I'm going in to see. The notes could be about some current event and how this event dovetails neatly with the story I've come to tell. Almost anything I can think of that gives currency and immediacy to my story, I write down. Most of the time, I don't even use these

notes once the meeting begins. In the meantime, however, I've kept my mind lively, my anxiety in check and I've reminded myself that this isn't the most important day of my life, upon which all else hinges.

Here are some reasons *you* might have for bringing a pencil and a notebook to the meeting:

• You might see something in the trades while you're waiting for the meeting to begin that you need to follow up on later.

• You will want to write down the names of any people you're meeting for the first time. You'll want to give these names to your agent and you'll want to remember them in the future.

• You will want to write down any thoughts that come up in the meeting so that you can give them full consideration before the next meeting.

• You can always write limericks to amuse yourself if the meeting is going badly.

So we're agreed on the concept of bringing a pencil and a notebook. And obviously you're going to bring your idea with you. That's the whole reason you're there. But do you have to bring actual pages? The IDEA written down?

Yes.

I'm not a proponent of leaving pages behind. Many people ask for them. I'd rather come back and pitch it again than risk leaving pages which aren't going to breathe life into the story. Even so, I think it's a good idea to have the pages there for yourself.

I write all my pitches on three-by-five-inch index cards and then I eliminate most of the words one by one until I've distilled the pitch down to one or two cards with a few phrases that will remind me of what I'm going to say.

I'll highlight certain words to help me remember to make a transition or to emphasize a vital aspect of the story or the character.

By the time I've distilled my notes and rewritten them five or six times, I've memorized the pitch. But the cards are my safety net. If I get distracted or have a momentary lapse of memory, the highlighted words are sitting there, waiting for me.

I've also noticed that the people I'm pitching to are more comfortable if they see notes in front of me. They know I'm not going to get lost and go rambling on while I find my way back to the story. They know I've spent time with the story and I'm not pitching an idea I came up with on my way up from the parking lot. Whether they like the story or not, whether they

buy it or not, they know I'm a professional and I haven't wasted their valuable time.

My friend Eric Tuchman (*Early Edition*; *Dr. Quinn, Medicine Woman*) came to the same conclusion about bringing in notes. He brings in more extensive notes than I do, but here's his story:

Unlike me, there are writers who enjoy pitching. They get all pumped up. Some of them can even go in and wing it at a pitch meeting. I hate those people. Because when I first started pitching feature ideas, I felt very self-conscious and inarticulate during the meetings. I felt like I was watching and listening to myself the whole time, critiquing and analyzing my own performance, which only made me more tongue-tied and stressed. It was about this time I had a vivid dream. Scratch that. Nightmare. I was sitting at a conference table, facing the stone-faced executives, and beside me? Gene Hackman. Yes, that's right, Gene Hackman. In the dream, I'm pitching my heart out, when Gene Hackman leans over to me and whispers, 'Try not to sound so dumb.'

Okay, I don't know Gene Hackman, I've never met Gene Hackman, and I wasn't working on any idea for Gene Hackman. He must've represented some sort of fatherly authority figure to me. I do know that the dream shook me up. But I soon realized there was no reason for me to feel so inarticulate if I really took the time to PREPARE.

And for me, that means writing a word-for-word script of my pitch. Start to finish. I could rehearse it, play it out in my head, practice it in the shower, then again in the car and get as comfortable as possible before the meeting. And I take that script into the meeting with me. I never read from it. I adjust it and edit it when necessary, and I try to sound spontaneous. But I have the script with me, like a safety net.

Another great reason for bringing your notes along with you is to keep you on message, as they say in politics. *Abbott's Second Law of the Unpredictable Universe*: If you *can* say something inappropriate, you *will* say something inappropriate. Example: I was in a meeting not too long ago with writer/producer Barry Kemp *(Taxi; Newhart; Coach)* He mentioned something about having gone to the premiere of the film *Catch Me If You Can* the night before. "Oh," I said curiously. "Did you like it? I heard it wasn't very good." There was a sudden awkward hush in the room. Then one of his assistants said quietly, "Well, he *should* like it. He produced it." See what I mean? Stick to your notes.

A final word on bringing *your idea* with you: make sure it's your idea and not an idea you've hobbled together from movies and television shows you've seen. It's your voice people are looking for; your vision of the world. Don't be afraid to give it to them.

"Don't say the old lady screamed. Bring her on and let her scream."

—Mark Twain

4. Go to the Restroom

If I'm way early for a meeting, I prefer to go to the restroom rather than wait in the lobby. Most studios have nicely appointed bathrooms with soft lighting and overstuffed chairs. I like it there because it's usually empty and it's very quiet. The people who are coming and going into the restroom usually aren't trying to impress anyone, so there's a kinder, gentler atmosphere. Take advantage of that fact to calm down and go over your notes.

And as long as you're there, take the opportunity for one last check in the mirror:

- Zippers up!

- Dandruff off!

- Dental danglers out!

- Lipstick on!

- Beard Crumbs gone!

- Hair tamed!

And last but not least: use the facilities! You never

know how long you're going to be sitting in someone's office waiting for him/her to get off the phone. You don't want to have to excuse yourself in the middle of your own pitch just because your bladder has gone into overdrive. The pitch meeting is probably the only time in the entire process of making movies when the writer is the most important person in the room. Who's going to pitch if you're not there?

"He was such a bad writer, they revoked his artistic license."

—Milton Berle

5. Be Pleasant to the Assistants

I have always liked assistants. For the most part, they are much more likely to be honest with you about the reality of any given situation than are their bosses. They like to let you know that they are insiders and are therefore willing to share information with you if you keep it to yourself. And even when they aren't willing to spill their guts to you, you can almost always tell by their attitude exactly where you stand with their boss at any given time. They can't help but project their employer's current opinion of you. It has something to do with their genetic makeup.

I did know one assistant who did not automatically take on his executive's mood. At one point, bless his heart, he even put me on hold, went to a phone in a more private place, and let me know that my pilot was a favorite no matter what the executives were saying to me and that I should not lose heart, everything was going very well. I will always be grateful to him for that act of humanity.

Some of the ways you can be pleasant to the assistants:

- Recognize their voices when they call you on the phone.

- Remember their names when you see them.

- Be friendly, but don't assume they have nothing to do but talk to you.

- If time allows, talk to them about their interests outside the studio. See them as people, not tools.

- If you're sending holiday gifts to the executive, send something smaller but thoughtful to the assistant.

- Don't ever, under any circumstance, yell at them. Your problem, whatever it is, has nothing to do with them.

If it just isn't in your nature to see kindness as its own reward, consider this: assistants are notoriously overworked and underpaid. They are screamed at, ignored, taken for granted and blamed for everything that goes wrong. They're treated almost as badly as writers. Any kindness you can pass their way is not only a good thing for them, it's a good thing for you. It gives you a sense of dignity as you're about to enter the torture chamber. And believe me, any dignity you can muster at that moment will be sorely needed. Need some more practical reasons?

- Assistants are in charge of getting you paid.

- Assistants always read your script before their bosses do and are often asked for their opinion.

- Assistants can get you research material and background material on the characters to enhance your script.

- Assistants often choose which shows are repeated during the season, triggering residuals.

- Over the years, assistants almost always move up into positions of power. When they're deciding who to hire, you'll want them to remember what a pleasure it was working with you.

Need any more convincing? Here's what my friend Burt Prelutsky (*Mash; The Mary Tyler Moore Show*) has to say on the subject: "*I was invariably cordial to the assistants. And not just because you never know when the assistant is going to wend his/her way up through the corporate food chain and have assistants of his/her own. In one notable instance, I was so damn cordial to the assistant of the V.P. in charge of TV Movies at NBC—the lovely Yvonne Partridge—that I wound up married to her.*"

You might not be so lucky, but then again... who knows?

"Writing is the hardest work in the world. I have been a bricklayer and a truck driver and I tell you —as if you haven't been told a million times already—that writing is harder. Lonelier. And nobler and more enriching."

—Harlan Ellison

6. Don't Forget to Breathe

All right, you've gotten to the building on time, you've schmoozed with the assistants, what's next? Breathe.

"Swell advice," you're saying to yourself. "I breathe all the time." You think so? I thought so, too. Then, about ten years ago, I noticed that I was having a difficult time catching my breath. So I did what any concerned person would do with a medical problem: I hit the Internet. Surfing medical sites, typing in my symptoms, I came to the conclusion that I had either emphysema or lung cancer. Resigned to facing an early death, I went in for tests to confirm my own diagnosis. Nothing. No emphysema. No cancer. No breathing problem. Impossible. How can a doctor tell me I'm not having a problem breathing when I'm having a problem breathing?

If it wasn't cancer, maybe it was asthma, I pointed out. Much less dramatic, but still you can get those little inhalers to carry around and use to breathe when the toxic Los Angeles air overcomes you. More tests. No asthma. No allergies. This was getting ridiculous. I couldn't breathe! There had be some problem.

"Anxiety," the doctor assured me.

Anxiety? That's ridiculous. I wasn't anxious. I just couldn't breathe.

The doctor finally convinced me that the reason I couldn't get a deep breath was because I wasn't breathing out. I was taking air in, but not fully letting it out again, which meant I had an excess of carbon dioxide in my system sending messages to my brain that I wasn't breathing.

Why was I anxious? You got it: constant rejection. It turns out that there is nothing that will make you start holding your breath faster than constant rejection. But holding your breath isn't going to sell your story, so you might as well stop tormenting yourself. And how do you stop the behavior?

Spend a little time every day breathing in and breathing out. Start your morning with 20 extremely deep inhalations during which you exhale to the point of feeling light-headed. Here's what you get: endorphins. Yes, those tiny, little happy guys that remind you that you're a joyful, healthy human being full of energy and creativity. Isn't that worth five minutes of your morning? You can even do it in bed before you get up. How difficult is that?

Benefits of breathing in and breathing out:

- You will banish those feelings of anxiety.

- You will have more energy.

- You will look and feel more confident.

- Your skin will actually look better.

- You'll feel in control of your day.

Now that you've mastered the first step, try it again just before you go in to pitch. You can even continue taking deep breaths throughout the meeting, especially if you're feeling confused, attacked or abused. Remember, you can survive anything for ten seconds. So breathe in, breathe out, count to ten. You've survived. Now do that again and again as many times as you have to until the meeting is over. Piece of cake.

"Don't do what you can do—try what you can't do."

—William Faulkner

7. Know the People in the Room

Greet each person by name. You know why? It gets you out of yourself. Look at each person. Really look at them. Notice something about them even if you don't mention it. The only purpose of this is to make you stop thinking about what they're thinking about you! The residual benefit is that people are impressed when you know their names. And if there's even one thing that you know about them, or one acquaintance you have in common, it puts you leagues ahead of every other writer who's entered the room that day. Executives want the meeting to be comfortable and to go well, too. Surprise them with manners and charm.

It's also important for you to know the credits of the people in the room. What projects have they developed or written or produced that you particularly like? Of course, even the best research can go awry from time to time. One staffing season, my agent sent me in to interview for a new series on one of the major networks. I went into the interview full of confidence. I liked the series this man was producing and I had really liked an earlier series he had created.

In the room, I talked to him about his earlier series and how creative I thought it was. He was startled by this admission. Not too many people had seen the style and the humor in the series that I was now extolling. After waxing poetic for several minutes on his brilliance, I started to mention that I had been friends with one of the producers he had hired to run that show, but something kept me from saying it. A rare moment of caution given my proclivity for saying every word that pops into my brain.

After I left the meeting and was walking across the parking lot to my car, it hit me: the series I had been praising to the skies was not the series this man had created. He had created another series at the same time, on the same subject, with a similar title. But the series themselves were miles apart in tone and quality. Had I mentioned the name of my friend who had produced the other series, this man would have known immediately that I was talking about the show that rivaled his and which, in very short time, garnered all the ratings and effectively killed his show. Wouldn't he have loved to have heard *that*?

I made a more successful connection earlier in my career. I was pitching a miniseries idea to the head of one of the three major networks. Someone had told me that this network executive was going through a nasty divorce, that he had had an affair

with a well-known TV personality, which act had killed his marriage. Not surprisingly, I might add.

The series I was pitching had at the center of it a noble man, a family man, a man who held fast to old-fashioned values and morals but who, in the course of the story, is tempted to have an affair with one of his employees. Recognizing the similarities between the character in our story and the network executive, I knew I had my hook.

I started pitching the story about a man who is honorable and loves his wife but finds himself, through no fault of his own, falling in love with someone else. The executive started nodding in understanding and empathy for our main character and he bought the miniseries practically before I had finished pitching it. How could he not? He was hearing a story about a man just like himself.

If you hit a brick wall and can't find out anything about the executive, take the time in the room to look around and see if you can discover anything that points to a common interest.

Executives have nicely decorated offices with photos of their kids if they have any and knickknacks of one kind or another which should give you clues about their extracurricular activities. One of the executives

at Universal Studios collected trains. Another executive there had recently become a first-time father. An executive at CBS had several lithographs on his wall of a favorite painter of mine. There are books on their shelves. There are coffee cups on their desks. There are hundreds of things in that room that you can talk about if you think there's any value in it. If this seems calculated to you, remember: every person on this earth is pleased if you take a little bit of time to get to know who they are. This isn't only about making a sale, it's also about behaving like a human being instead of a human doing.

And, from a craft perspective: what better way to begin to think about the intricacies of character than by observing the intricacies of those around you.
To recap:

- Make sure you get the names of all the people you're going to be meeting with.

- Do your research. Find out the projects these executives have greenlighted.

- Give some thought, in advance, to what you might want to say about the movies they have already produced.

- See what you can learn about them personally from the things they have in their office.

Taking the time to observe the room has two benefits: it slows you down and helps you get centered; and it helps the executive see you as a person, not just another writer coming in to pitch an idea.

Before we leave this guideline, I want you to think about this angle: You're not always going to be pitching your idea to a studio or network executive. Sometimes you'll be pitching to an actor. Sometimes you'll be pitching to a director. Sometimes you'll be pitching to another writer. If you're working in television, you will find yourself pitching to the line producer whose sole responsibility is to make sure the project comes in on time and on budget. You can stumble and fall by pitching the story from the wrong point of view.

Through trial and error, I have come up with some general rules to follow when determining how to make the pitch.

- Writers/Producers: Emphasize the most original scenes, the coolest surprise, the tightly knit structure.

- Actors: Show how the story hinges on their unique abilities; what award-winning scenes they have. Get them to visualize themselves in the movie.

- Directors: Give them the exciting visuals. Encourage their creative talents (by letting them

see how the camera can be used in unusual ways.)

- Line Producers: Cut to the bottom line. Show them you know how to take the visuals you've promised the director, the dramatic scenes promised the actor and the cool story turns promised the writer/producer and still deliver a script that brings the whole thing in on time and on budget. It's a good thing if you actually know how to do that, but it's not necessarily a requirement!

The most important thing to remember is this: if you know who you're pitching to, and you tailor the pitch to their needs, you have a much better chance of selling your story and starting on the road to production.

"The worst thing you write is better than the best thing you don't write."

—Anonymous

8. Turn off Everything but Your Mind

It's easy to forget to turn off your cell phone. Especially if you never receive any calls. I've never made that mistake, fortunately. Something did happen to me once, however, that was rather comical even at the time.

I didn't have a cell phone; I had a pager. This was a dandy pager with storage space for an extra battery so you would never find yourself without power. I was getting notes on my pilot prior to going to series at UPN. I had turned the pager to vibrate mode so that there was no chance of it going off and interrupting our meeting. Well, of course, halfway through the meeting the pager began to vibrate. And the vibration noise was so loud everyone in the room stopped talking and looked at me. I smiled sheepishly and hit the button to let the pager know I had received the page. It stopped vibrating. We went back to notes. Not more than two minutes later the pager went off again, its vibrating noise bringing everything to a halt.

Tom Noonan, Head of Development at that time, turned to me and said in a peevish tone, "Either answer it or turn it off!" I have to admit, the sound was annoying. I couldn't figure out why it was so loud. It turns out, it was the extra battery. With two batteries in place, any page caused them to vibrate against each other, making a surprisingly loud noise. Ever after, I traveled with no battery backup.

These days I just turn everything off. If someone is trying to reach me, my phone will take a message even in the "off" position and I can return the call after I've left the building. I can just imagine trying to get through a pitch with my phone vibrating in my purse. How could I not wonder what disaster or incredible good fortune was vibrating for me, just waiting for me to break off my meeting and grab my phone?

Side note: Don't expect the executives you're meeting with to afford you the same courtesy with respect to phone calls. Well-known comedy writer Charlie Hauck (*Frasier; Home Improvement*) once pitched a series idea to a known-to-be-quirky star at her beach house. She had a pedicure while Charlie pitched and when a phone call came in for her, she asked him to wait outside on the beach while she took the call in private.

A friend of mine, Carl Binder (*Adderly*; *Just Cause*), was in the middle of a pitch when the producer took a phone call to break up with his girlfriend. Carl had to sit and smile through the incredibly personal conversation and then try to bring the producer back to the pitch.

I once waited from ten o'clock in the morning until five o'clock in the afternoon to do a pitch and finally ended up pitching the story to a group of six executives over sushi in a crowded and very noisy restaurant. But the rules that apply to them don't necessarily apply to us. So remember:

- Cell phone off

- Pager off

- MP3 Player off

- Brain cells on

You're ready! Go get 'em.

"I love being a writer. What I can't stand is the paperwork."

—Peter de Vries

9. Don't Start Pitching Until You're in the Room

When I first started out, I was so nervous, I'd start pitching as the assistant showed me into the room. A kind executive finally explained to me that you don't have to start telling your story until you're actually in the room and seated. Despite grueling schedules, there still is time, even in Hollywood, for a moment or two of polite small talk.

Be sensitive to the mood in the room, however. You should be the one to transition the conversation from small talk to business. It gives your prospective employers the sense that you are capable of keeping things moving along.

But getting seated and moving past small talk is not the primary principle of this guideline. There is a much bigger issue for you to confront. Here's what happens: you have a great idea. It's such a great idea that you have to tell it to your significant other before you sit down and write it. He/She agrees that it is indeed an incredible idea.

Filled with enthusiasm, you now have to call eight or ten of your closest friends and tell each one of them, in minute detail, the story and how it unfolds. By the time you've finished telling everyone you can think of about your story, you've completely run out of steam. You have absolutely no desire to write it anymore. And so it slowly withers away in a filing cabinet in the back of your mind.

There is another way to define this idea of pitching before you're in the room. Sometimes you've practiced your pitch so many times it has become stale by the time you actually have a meeting. Why would anyone practice their pitch too many times? I can give you one reason.

When I first started writing, I had no idea whether I had a good idea or not. They all seemed both inventive and banal at the same time. The only way I could figure out whether a story was good or not was to tell it to as many people as I could get to listen to me and see what their opinions were. This is almost as futile an undertaking as democracy. How can any other human being tell you whether or not your idea has merit until it has been written and produced? And by the time you've collected everyone's ideas and suggestions, you no longer have an idea at all. You have Frankenstein's Monster. So what's the solution?

- Don't tell your best friend, your mom, your cleaning lady and the security guard at the gate your story. You'll get bored with it.

- Don't ask everyone you know for advice. You'll get confused.

- Don't start pitching the minute you walk through the office door.

- If you think you're going too slowly, you're probably going too fast. Slow down. A pitch isn't a race, it's a dance.

There's no way to protect yourself from rejection. In his best-selling book, *Adventures in the Screen Trade*, William Goldman posits the notion that in Hollywood "Nobody knows anything." While that can be comforting when you're being shot down, I submit that somebody does know something. You do. You know if your story is worth producing or not. You may not be able to convince anyone else. But unless you know its value, there's no point in scheduling meetings to sell it. Have confidence, believe in your judgment and then let go of the results.

"You only learn to be a better writer by actually writing."

—Doris Lessing

10. Tell the Story You've Come to Tell

Before they've even agreed to meet with you, the executives you're about to pitch to have already been alerted to an "area" or a "genre." They're far too busy to waste time listening to science fiction when they know they're only going to buy cop dramas. Take the right story to them, and tell it!

Television veteran writer/creator Dean Hargrove (*Jake and the Fat Man*; *Matlock*) has some nuts-and-bolts advice about how to tell the story you've come to tell. He believes that within the first three minutes of the pitch, you will have either succeeded or failed. Consequently, he does a very direct pitch.

After the warm-up banter, he says, state clearly what the project is. "This is a one-hour mystery series about a doctor who solves crimes" is how he described *Diagnosis Murder*.

Continue the pitch with: "A pilot story would begin something like this." And then proceed to tell them what that pilot story is. Entertaining but brief is

Dean's standard. His approach:

- Headline the story;

- Give them an engrossing opening;

- Introduce the characters in a visually interesting way;

- Hit one or two plot points;

- And you're done!

David Rintels (*Not Without My Daughter; Nuremburg*) has a less direct pitch style. David believes there's nothing that will turn a development executive off faster than the words, "This is a story about..." His method is to describe the scene visually and pull the executives into the movie. Once they're hooked, it's a lot easier to make the sale.

I've always used a combination of both styles. I like to tell the executives what arena we're discussing so they're not trying to figure it out for the first five minutes of the pitch. This is a thriller. This is a family show. This is a series about a bounty hunter and a stringer for the *National Enquirer*.

Let the people you're pitching to know the universe you're taking them into. Then I pull them into the dream with a visually interesting and surprising first scene. I want them to expect one thing and be

completely misdirected. If I can pull that off, I'm pretty sure they'll want to know more.

And then I get a little vague. In most cases, less is more. You want them curious enough about the story to write a check for you to develop it. But you don't want them so confused that they don't want to think about it. There are other elements I like to bring into the discussion:

- What is the tone of the idea?

- Is there a moral dilemma?

- Is there a mystery to solve?

- Is there a personal demon to do battle with?

- Is there an actual demon to do battle with?

If you are pitching a television series, you'll also want to tell them where the ideas will come from week to week. You want the executives to understand how your idea can turn into a long-running series.

A corollary to this guideline is this: If you're working with a partner, make sure you're both telling the same story!

Partnership has its own challenges. For example, if one of you is going to do all the talking, it's generally a good idea that the other person look at least

remotely interested in what's being said. If you can't even amuse your own partner, how do you expect to amuse a vast, paying audience? I had a writing partner once who sat through the entire pitch staring at me with a stunned, incredulous look on her face which seemed to say, "Who would ever buy this?" It was unsettling to say the least.

A young writing team I worked with, Becky Southwell and Dylan Neal (*Relic Hunter*; *So Little Time*), are naturals at speaking in one voice. They share the pitch, interrupting each other, verbally leapfrogging over one another. It looks completely spontaneous in the room. The truth is, however, that they practice their pitch, word for word, over and over, even videotaping themselves and playing it back to make sure everything looks natural and unrehearsed. And let me tell you, everyone loves to hear them pitch.

On the whole, I'd rather pitch with a partner than by myself but I'd rather write by myself than with a partner. So ultimately, I'm in a room by myself sweating out the small stuff.

One last secret: See if you can get the executive to say "yes" to something early on in the pitch. Something like, "You know how people look forward every year to their vacation." (Who wouldn't say "yes" to that? Just make sure it ties in to your pitch.)

It's just a hunch of mine, but I think once they're saying "yes" to anything, it'll be easier for them to say "yes" to buying the story. Try it! I think you'll see I'm right.

"Even if you are on the right track, you'll get run over if you just sit there."

—Will Rogers

11. Expect the Unexpected

This is my favorite guideline. No matter what you expect, you cannot expect what's going to happen. You expect the phone to ring, you expect interruptions, you might even expect people to ignore you or say rude things to you. But would you expect this… Two friends of mine, a writing team, were pitching to a studio executive. The executive explained that she had somewhere to go after the meeting. She asked them to continue their pitch while she changed her clothes behind a small screen in her office.

Another writer was pitching to an executive who received a phone call in the middle of the story. He asked the writer to continue the pitch while he took the call. Because they were the only two in the room, the writer continued pitching to thin air while the executive talked on the phone.

A friend of mine told the story about a time early in his career when he was pitching a movie idea and one of the executives in the room fell asleep. Everybody just pretended not to notice the sleeping guy and my friend kept pitching. That's not the

unexpected part, this is: they bought the idea. Don't assume just because people are sleeping, they're not going to buy something from you!

My friend Joel Steiger (*Diagnosis Murder; Knots Landing*) was pitching story ideas with a partner shortly after he arrived in L.A. After an unsuccessful pitch at one studio, his partner offered to do the pitch at the second studio. Relieved of the burden, Joel readily agreed. He was stunned to hear his friend, his *mentor*, pitching a completely different story. The studio bought it. Upset, Joel confronted his friend. "That's not the story I came up with. That's not the story I want to write!" "Don't worry about it," his friend assured him. "Write the story you want to write. Write it well. They'll be so happy they won't remember which story they bought." In this case, he turned out to be right.

Burt Prelutsky has a wonderful story about predicting success in the room. You should know that it's generally considered bad form to read your pitch. You're supposed to *perform* it. Everyone knows that. Well, everyone but Burt, I guess. This is his story:

To me, the hardest part of writing for TV was pitching. I invariably wound up feeling less like a writer and more like a snake oil salesman. If I had prepared for the occasion in the manner I felt appropriate, I'd have come

in with garters on my sleeves, chewing on a stogie, and the first words out of my mouth would have been: I'll tell you what I'm gonna do. For ten cents, one thin dime, one-tenth part of a dollar, you not only get to hear the swellest idea for a TV series the fertile mind of man has ever conceived, but you get to take a gander at Bobo the Dog-Faced Boy and feast your eyes on Sheba the Snake Lady as she performs her famous hoochy-koochy dance.

My oddest pitching experience was a two-part affair. Part one began in the office of the V.P. in charge of Comedy Development at CBS. It seems our group of four hadn't really planned out the campaign too well. For after the mandatory 15 minutes of comparing golf scores and asking about the kids, the other three guys turned to me, as if on cue. Unfortunately, I thought one of them was going to do the hustle. I was wrong.

I turned to the network executive and asked him— gulp!—if he'd mind if I simply read my three-page treatment aloud. (Out of the corner of my eye, I saw my teammates blanch.) The V.P. said he had no problem with it. In fact, he cupped his hands behind his head and put his feet up on the coffee table.

As I began to read, the V.P. began to laugh. What's more, he never stopped. Before I knew it, he had fallen off his chair, he was laughing so hard. By the time I had finished, he was pounding his fists on the floor and gasping for

breath. If any person could truly die laughing, I thought he could be the one.

I figured even if CBS didn't order a script, I could always play Vegas. I'd go out on stage, sit down on a stool and read my three pages. I'd kill 'em.

The four of us left the meeting truly convinced we'd just sold CBS their next MASH.

Two weeks later, we got word that CBS had decided to pass. It seems they already had something similar in the works. Or perhaps someone's astrologer had spotted Venus sneaking into Pluto's house. With these people, anything is possible.

A few days later, I got the call that we were going to pitch at NBC. This time, there were only two of us. I don't know what happened to the other half of our team. Maybe they didn't want to get their hopes up a second time only to have them dashed once again on the rocks of network stupidity. Frankly, I didn't care. I didn't need cheerleaders; I had my three pages of killer material. On his best day, Willy Loman couldn't have been any cockier.

When we sat down in the office of the NBC executive, I couldn't wait to get started. The V.P. seemed just as eager to cut through the small talk and get straight to me. I explained I would read my treatment aloud. He didn't

seem too happy with the idea. He definitely didn't cup his hands behind his head and he certainly didn't put his feet up. No matter. Soon enough he'd fall to the floor, tears running down his face, kicking his feet, begging for mercy.

I began to read. Strange… I was halfway through the first page and I hadn't heard a single guffaw or even a chuckle. I heard nary a titter. I glanced up. He looked positively glum. If I'd just run over his dog or had made a mess on his carpet, I would have understood. Gloom quickly descended. Suddenly, I found my mouth had filled with cotton wadding. It was like trying to carry on a conversation with your dentist. And I still had two-and-a-half pages to go.

The faster I tried to read, the slower the words seemed to ooze out of my mouth. If, at the end, somebody had announced that I'd been reading for nine hours, I'd have said, "Funny, it seemed longer."

When I finished my performance, the executive muttered a few parting words, and that, my friends, was that. I couldn't wait to get out the door. I was drenched in flop sweat. All I wanted to do was go home and take a shower. I thought I might only pause long enough to kill the producer. After all, he had been a witness. And, as we all know, dead men can't tell tales.

Outside, in the corridor, the producer looked at me, a puzzled look on his face, and said, "What did he say?"

"I'm not sure what he said. I was going to ask you what he said."

"But what do you think he said?"

"It sounded like, 'Well, I guess we have a deal.' But that makes no sense, so I think he probably said, 'Get out of here, shlemiel.'"

The next day was Friday. The producer called Business Affairs at NBC. We did indeed have a deal to go to script on a pilot.

The trade papers that day reported that the V.P. of Comedy Development at NBC had been let go. To this day, I don't know if he greenlighted our project because, in spite of his own misfortune, he recognized the intrinsic value of our show, or if it was a final act of spite and revenge. Oh, sure, I have my own suspicions, but, as you may have noticed, I've been wrong before.

Another well-known axiom in Hollywood is that it is impossible to sell anything the first time out. You have to work, pay your dues, experience failure and rejection. That's the expectation. After he moved from New York City to Los Angeles, writer/producer Terry Curtis Fox (*Hillstreet Blues*; *Diagnosis Murder*) expected it would be some time before he made his first sale. Here's his story:

I was talking on the phone with a development executive after a very young playwright had won a Pulitzer Prize. I mentioned that when I'd been a journalist, I'd known two people whose lives had been ruined when they received Pulitzers too young.

"That's a movie," he said. We had lunch on the lot to discuss the prospect. At the end of lunch, he said, "Let's pitch this right now."

I wasn't ready, but I wasn't about to argue. I'd just moved to town; my first play had preceded me and had garnered excellent reviews. I wasn't going to waste an opportunity. The development executive introduced me to his boss. I started to tell my story and before I was out of the room, I had my first assignment.

I share this story with you to remind you that they aren't all horror stories! Sometimes you get to be Cinderella.

"The task of a writer consists of being able to make something out of an idea."

—Thomas Mann

12. Be Memorable

Usually this translates to "be brief," but not always. How can you stand out from the pack?

Charlie Hauck said to me, "Having an opening line is always good. A not-good opening line is, 'Have you gained weight?'"

Comedy czar Allan Burns (*The Mary Tyler Moore Show; A Little Romance*) has a horrifying example of how to be memorable. The most important thing, he says, is not to wear short-sleeved shirts. Here's why:

I had a treatment on a movie and I pitched the general idea of it to a very-well-thought-of director over the phone. He said, "Great, great. Come in and pitch it. I'll have some other people here." So I went into his office at Warner Brothers. He had a big office, a very nice office, with pale, cream-colored carpet. He couldn't have been nicer. He was very courtly, almost as if he were inviting me into his home.

There were a dozen people in the room; people with steno pads who were taking notes before I even began to speak.

I pitch terribly, especially movies. The movie pitch is just not my cup of tea. But I started in. All of a sudden, I was aware of the sound of my voice. You know when you begin to hear the sound of your own voice that you're in trouble. "Why am I doing this in so much detail?" I thought. Going into detail is deadly. But I couldn't seem to stop.

I was wearing a short-sleeved shirt and I found a scab on my arm. As I was getting deeper and deeper into this cesspool of a story, I began to pick on that scab absent-mindedly.

I'm trying to figure out how to get to the end of the story when I see eyes of those young minions start to widen— enormously. I look down to see what they're gaping at and I see that I've picked the scab to the point that it's bleeding all over this director's beautiful cream carpet. Before I can even take in what this means, I'm surrounded by people kneeling at my feet with bottles of soda water and rags, trying to scrub the blood out of the carpet before it sets.

The director is being very nice, pretending that it's okay and that I'm doing very well with the pitch. I suggest that perhaps we ought not to continue. He thinks perhaps I'm right. We'll reschedule.

Of course, we never did. In fact, I never pitched that idea again.

Here's some advice from writer/producer Steve Brown (*Cagney & Lacey; L.A. Law*):

An interesting story with vital characters is the most obvious way to be memorable; making the pitch amusing helps a lot as well. But sometimes, with a bit of thought, you can add a little lagniappe (a New Orleans phrase that means 'a little something extra') that makes your pitch easier to remember at the end of a long day. For example, one friend—a comedy writer—brought along his own laugh track in the form of a continuous loop tape that he would turn up and down at the appropriate moments as he spoke. Another comedy writer went even further and taped his entire pitch, then sat back and mimed it. I don't recommend either approach, but both sold.

Producers, story editors, studio and network executives spend their lives listening to pitches… one pitch after the other—all day, every day—for months on end. If you can do something to make your pitch stand out from the other six they heard today, the other 30 they heard this week, it obviously helps your cause.

I was once tasked with presenting an idea from my studio: a television adaptation of a successful series of very softcore porn Westerns that had been put out, one a month, by the studio's publishing wing. The titles of these books were all of the order "Longarm and the Desert Duchess" and "Longarm and the Indian Princess," while

the cover of each paperback (there were more than 100 of them at this point) was adorned with a drawing of our cowboy hero and a scantily clad woman in some sort of peril. None of the books I read were adaptable per se, but I liked the idea of a sexy Western, so I developed my own version of the setup, wrote an original story and the studio set up a meeting at ABC.

My pitch was going quite well when there was an unexpected knock on the door. A studio messenger delivered a large gift-wrapped box, with the instructions that it was to be opened immediately. Inside, I had stacked all hundred-plus Longarm novels, each with its titillating cover. We dumped them out on the floor, and the people in the office—both my studio people as well as the network's—could not resist picking them up and leafing through them. It didn't matter that people were paying less attention to my pitch; it had become almost secondary. What had happened was everyone could see how to "sell" the series to an audience. And the mountain of books made it appear that there were more than a hundred stories already written, ready to tell. The meeting was a great success. (I could only wish the pilot had gone so well... Perhaps I should have arranged to have a box of books delivered to every home in America...) But I remember it as the only time in my career that I got a commitment to a pilot while I was still in the room.

Obviously, not every project lends itself to such ballyhoo.

*But, like it or not, a lot of our business is built on ballyhoo;
it's obviously what the people we sell to use to sell our
projects to the public. Why shouldn't we use it to sell
them in the first place?*

Legendary Leonard Stern (*The Honeymooners*;
McMillan and Wife) talks about a pitch he gave early
in his career:

*The network was entertaining pitches from various
companies. I had never pitched before. I had never sold
anything before. This was my first time at the network, and
to tell you the truth, I was somewhat in awe that I was in
the same waiting room with people from MCA/Universal.
My awe increased immeasurably when I discovered that
MCA was pitching an hour show with charts and designs.
I didn't know how I could compete with charts and
designs. "I know," I thought to myself, "I'll tell them I
don't need the money. No. Leslie Stevens did that."*

*The MCA pitch lasted a considerable amount of time.
I knew I had to come up with something. A thought
occurred to me. I looked at it from all sides. "What
have I got to lose?" I decided. "I'm going to risk it."*

*Finally, it was my turn to pitch. There were eight people in
the room. In those days, you'd get an answer, 'yes' or 'no,'
within 24 hours.*

I looked at all those people. They looked at me. I went for it.

"I have three shows to sell you," I said. "Three?" one of them asked. "Yes. Two are already hits on the air, but you won't buy any of them in the current climate," I said. I could see they were beginning to wonder why I was there. "Now, I'm going to play my part and I'm also going to play your part."

They waited.

"The first show I have for you is called 'The Honeymooners.' Now, you say to me, 'Oh? A young couple just starting out in life?' I say 'No, no. They've been married for years. He's a bus driver...' And of course you say, 'Hold it. This series takes place in a bus station?' I say, 'No, it takes place in a one-room apartment. The lead character's best friend lives upstairs. He's a sewer worker.' You're going to have to say to me, 'Sewers? We're talking about seven or eight pm... people are going to be eating...' I say, 'Let me go on to my second idea.'"

"Now, my second idea, this is also about a married couple. They've been married about nine years. 'How many children' you ask me. 'They don't have any children,' I tell you. 'No children?' you say. 'After nine years?' 'He's an orchestra leader,' I tell you. 'Young man,' you say, 'show business shows just don't work.' 'Also,' I mention, 'he's from Cuba. He has difficulty speaking English.'"

By now, of course, everyone in the room was smiling and nodding, understanding the point I was trying to make. I paused a second, then said to them, "My third show is called 'I'm Dickens, He's Fenster.'"

Within 24 hours we had a sale.

Daryl Nickens (*The Parkers*; *A Different World*) told me of the time he had been asked to pitch a story that already had principals attached: rap artists. He did the pitch by recording a soundtrack of rap and then interpreting it for the network executives. I did something similar one year. I wanted to pitch a series idea about three young women, like the Dixie Chicks, who are trying to break into the country music scene. I produced a CD of songs with photos of prototypes for the three characters on the cover. The liner notes were story ideas for the series. The show didn't sell, but I still love to play the album.

Part of the fun of a pitch is coming up with ideas that will leave the memory of your pitch in their head for days or months or even years. One time I pitched a murder mystery to NBC. I pitched it as if the murder was a true story. I never said it was; I just intimated. Halfway through the pitch, the executives in the room were insisting that they remembered the actual case. Ten years later, I would run into one or another of those executives and they still remembered that

pitch as the best one they had ever heard. And yes, the pilot was written, shot and produced in part because I snagged them early on.

So how do you make yourself memorable?

- Find the essence of your story and figure out how to make it visual. You're selling to a visual medium.

- Figure out an interesting leave-behind that represents your story.

- Think of an unusual and, again, visual way to begin your pitch.

- Don't be afraid to take a gamble. You're taking one, anyway, just being a writer!

- Have fun. If you can't enjoy the process, you're in the wrong business.

"The best way to have a good idea is to have lots of ideas."

—Linus Pauling

13. Don't Leave Before You're Finished

Very few people would actually stand up and leave the room before they finished what they had started. But often people leave the room mentally when they begin to feel overwhelmed. It's a constant battle to maintain good manners and a civil tone in the face of ridicule, abuse or lack of interest, whether real or perceived.

The most common mistake writers make is to finish the pitch, thank the people in the room for listening and bolt for the door without giving anyone an opportunity to respond to the pitch. This is another place where pencil and notebook come in handy!

If the studio executives don't have any questions for you (although believe me, they will), ask questions of them.

- Ask which parts of the story sparked their interest most.

- Ask if they liked any parts better than others.

- Ask if there was any confusion that needs clearing up.

- Pose your questions in a positive way.

- Listen respectfully.

- Jot down what they say.

If you leave the room before you've hooked them into a partnership with you, it's going to be that much harder to close the deal.

But the more common occurrence is going to be your desire to cut your pitch short and slink out of there the second you detect that it isn't going well. Bad idea. Why? First of all, you can't trust your feelings in that moment. You don't know whether it's going well or not. So hang in there. Secondly, even if it isn't going well, hang in there. As my mother used to tell me, "You're only allotted so many times in life to fall flat on your face; now you have one less time to worry about."

That aside, the experience of pitching is worth it whether or not the people you are pitching to behave well. Their behavior only reflects on who they are, not on what you have brought to them.

Writing is a lonely life. You have to have faith in yourself and in your ideas when no one else does. You have to sit alone for hours on end concocting stories or writing them. You have these small

windows of opportunity when you are thrust into the spotlight to amuse and entertain a room full of strangers and then, if they don't immediately buy your story, you feel like you're a failure. And if you should, by some miracle, actually sell your script and it gets made, when you go to the wrap party, no one is going to talk to you because who knows who the writer is, anyway? There's an old joke that's more true than it is funny: "Did you hear about the naive actress who slept with the writer to get ahead?"

As difficult as it is to do, you have to find a way to not take any of it personally and to not take any of it terribly seriously. There will be other ideas, other pitches, other days. But if you allow the daily grind to wear you down, you will have neither the joy nor the energy to write anything for anyone. Not even for yourself. That would be a shame.

"Writing is easy; all you do is sit staring at a blank sheet of paper until the drops of blood form on your forehead."

—Gene Fowler

14. Make a Graceful Exit

No matter how debilitating the meeting has been, you still have the trump card: the graceful exit. Ask one final personal question, like, "Are you going to be able to go skiing again this weekend?" You want it to be a personal question, not a work-related one, for this simple reason: you don't want to leave the impression that you have no life outside this office. It's important for them to know that, but it's even more important for *you* to know that.

And then there's this: if you slink out of the room like a loser, that's how they're going to remember you. They might not remember you one way or the other. But just in case they do, give them the Full-of-Confidence You, not the Whiney-Why-Can't-I-Be-Rich You. While you're at it, be sure to smile as you leave. It doesn't hurt to have them wonder, even if only for a second, if they've made a horrible mistake in not hiring you on the spot.

To make a graceful exit, you should:

- Smile at the executives, shake hands if it seems appropriate.

- Get your parking ticket validated and while you're doing that, validate the assistant who helped set up this meeting.

- Say something nice to the security guard on your way out. Take time to actually look at him/her and notice something about him/her. How old is he/she? How long has he/she been doing this job? Is he/she happy? Or does he/she have dreams of doing something else with his/her life? Don't ask him/her; just consider it.

There's a practical advantage to this endgame strategy as well as the more obvious psychological one: paying attention to the world around you just might give you some material to write.

I have believed for some time that one of the problems with television is that screenwriters never have time to live a real life. Their stories, therefore, are based on other television and film stories because they don't have any stories of their own to tell. You don't have to go off on an African safari to have a story to tell. Look around you. Breathe in, breathe out. Listen to what people are saying to you; find a rejoinder. Some people think of it as conversation. I like to think of it as potential dialogue.

And the by-product of all this civility? Yes, I know

you know: you get to be pleasant to someone who might really need that right now.

"A blank piece of paper is God's way of telling us how hard it is to be God."

—Sidney Sheldon

15. Have Someplace to Go After the Meeting

This might be the most important guideline of all. It's related to other strategies I've mentioned, like having several stories going at once. Then if one doesn't sell, it's not the end of the world.

If the success of the meeting you've just had is all that stands between you and suicide, you're an actuarial nightmare. You're going to have way more failure than success. It's a numbers game. How many times can you get back up and go in with another pitch? You have to have at least one more in you every single time.

And how do you find the stamina and the courage for that "one more pitch"? Easy! Have someplace to go to remind yourself that:

- You're a human being

- You're creative

- People care about you

- You have value

Sometimes I want to be immediately in the warm embrace of people who love me. In that case, I'll plan to meet someone for lunch or coffee or a movie.

Sometimes I want to be by myself. In that case, I'll plan to go to the museum or do some shopping or see a movie.

The very best thing you can do is to have a regularly scheduled appointment to do some kind of charity or volunteer work. In today's world there's a ton of opportunity for working with underprivileged kids, the elderly, people who have terminal illness. Not only does this kind of work bring you out of your own obsessive thoughts about how your meeting went, you're actually doing something for the better means of your fellow human. And, from a completely selfish point of view, you're gathering stories which may prove commercial someday.

Whatever you choose to do, make sure you're nurturing your soul with beauty, creativity, friendship, intellectual pursuit, compassion and joy. That way you'll have something to talk about when you win your first Oscar.

Know the Marketplace

Are you the first person to pitch your idea to the studios? Or are you the fourth or fifth or seventeenth writer who has come in with the same brilliant idea? There's something to be said for being the first guy through the door.

But how can you be sure you're the first one in line? You can't. But there are a couple of rules, if followed, that will better your odds:

- When you have a good idea, don't sit on it. Flesh it out. Set up, or have your agent set up, some meetings while the idea is still fresh.

- Don't blab your story to all your friends and relatives. Good ideas are like viruses. They make their way into other people's heads. These other people will try to sell the idea themselves. They may even think the idea is their own.

- Be aware of the marketplace. Know what movies are being made and which movies are doing well at the box office. Read the trades. Surf the Internet. Find out what's in development, what's being bought and by whom.

- Watch trends. Look around you. Observe your friends. Pay attention to your family. Any insights you have about marriage, children, work? While there is nothing new under the sun, there may be a new take on an old idea. Develop your own perspective in life; your own voice.

- Ask any 12-year-old kid what he's into. I can guarantee you that's next year's big fad. Sell it to the studios before that 12-year-old kid does.

- If you're pitching to a television series, call the writers' assistant and ask for a "Bible" of the show. Most series keep a Bible which is a log of all the episodes they've produced with a short synopsis of each. They will be happy to send it out to you.

There are consulting firms and well-known talking heads who claim to have an insider's scoop on the trends of the marketplace. They don't know any more than you do. Stay awake, look around you, analyze what you're observing and then tailor it to work for you. The marketplace is fluid and ever-changing, but it's not unknowable.

The Days (And Weeks) Before

Obviously, the guidelines I've given you are only
useful if you've done the weeks and months of prep
work necessary to get that pitch meeting scheduled.
That amount of prep may seem daunting, but take
heart. This section of your guidebook will direct you
to all of the resources you need.

Know the Industry

It is of paramount importance for you to know, both specifically and generally, what kinds of things are being produced and by whom. This is a shifting landscape, so you'll not only have to research it, you'll also have to keep updating your research. Fortunately, there are good sources available to you to do just that. They include:

PK Baseline, www.pkbaseline.com
This is a pay subscription service, but worth every penny you spend. You pay only for the articles you download and print. THEIR DATABASE INCLUDES:

Film

In Development	5,000 entries
Pre-Production and Production	300 entries
Wrapped, Pre-Release	2,300 entries
Released	50,000 entries
Inactive, In Turn Around, On Hold, Dead	4,000 entries

Television

Pilots	1,600 entries
Series	9,000 entries
TV Movies	6,500 entries
Miniseries	700 entries

Additional Information, etc.

Film Revenue and Cost Estimates
Box Office Data
Biographies
Credits
Awards
Film Festivals
News Archives

Internet Movie Database

www.imdb.com
Useful for finding out what has already been done
and for linking names together to find shared
projects, but not as helpful in finding what's in pre-
production or in production. It's free, however, and
therefore worth looking into.

Individual Domain Names

All of the studios, networks, unions and many
individual artists have official Web sites. Use any
search engine (Google.com is good), enter the name
of the person or organization you're looking for and
hit "search." You will have hundreds of addresses to
choose from. (So that you don't have to go through
that whole rigmarole to find me: try
www.chrisabbott.com)

PUBLICATIONS

You can keep current with who's who, who's in and who's out and what's being produced by reading the trade magazines. Available both online and by mail subscription, I've given you contact addresses on the most well-known and highly respected trades. There are many, many more, but you can't go wrong by sticking with the industry standards.

Daily Variety
5700 Wilshire Boulevard, #120
Los Angeles, CA 90036
(323) 857-6600
www.variety.com

Daily Variety/Weekly Variety
360 Park Avenue South
New York, New York 10010
(656) 746-7002
www.variety.com

Hollywood Reporter
5055 Wilshire Boulevard
Los Angeles, CA 90036
(323) 525-2000
www.thehollywoodreporter.com

Written By Magazine
Writers Guild of America, West
7000 West Third Street
Los Angeles, CA 90048
(323) 951-4000
(800) 548-4532
www.wga.org

DGA Magazine
Directors Guild of America
7920 Sunset Boulevard, 5th Floor
Los Angeles, CA 90046
www.dga.org

Emmy Magazine
Academy of Television Arts and Sciences
5200 Lankershim Boulevard
North Hollywood, CA 91601
(818) 754-2800
www.emmys.com/emmymag

BOOKSTORES, MUSEUMS AND LIBRARIES

Samuel French is a play publisher and playwright's representative. They sell paperback copies of thousands of titles of plays and they also sell—in both hardcover and softcover—nearly every book published relating to the film and television industry. You can find them online or at these addresses in various cities around the world. Plan to spend a couple of days; there's way too much to look at in one day.

Samuel French, Inc.
7623 Sunset Boulevard
Hollywood, CA 90046
(323) 876-0570
www.samuelfrench.com

Samuel French, Inc.
11963 Ventura Boulevard
Studio City, CA 91604
(818) 762-0535
www.samuelfrench.com

Samuel French, Inc.
45 West 25th Street
New York, NY 10010
(212) 206-8990
www.samuelfrench.com

Samuel French, Ltd.
52 Fitzroy Street-Dept W
London W1P 6JR England
(44207) 387-9373
www.samuelfrench.com

Samuel French (Canada) Ltd.
100 Lombard Street, Dept. W
Toronto, Ontario, Canada M5C 1M3
(416) 363-3536
www.samuelfrench.com

The Museum of Television and Radio is a wonderful resource. In addition to programs, seminars and a shop where you can purchase videos of your favorite television series, they have a media room where you can order up and watch every single episode of almost every television show ever made. If you want to get a sense of a show and what stories they're producing, this is the place for you to spend many hours of your life.

Museum of Television and Radio (East)
25 West 52nd Street
New York, NY 10019
(212) 621-6800
www.mtr.org

Museum of Television and Radio (West)
465 North Beverly Drive
Beverly Hills, CA 90210
(310) 786-1025
www.mtr.org

The Writers Guild Foundation Library is still in its infancy and does not have the widest range of materials available. Still, it's nice to stop in and see what's on exhibit, glance through a few scripts, register your own story and rub elbows with your fellow writers.

Writers Guild Foundation Library
7000 West 3rd Street
Los Angeles, CA 90048
(323) 782-4544
www.wgfoundation.org

The Academy of Television Arts and Sciences houses its Library at the University of Southern California. They have a substantial collection of TV scripts, books, photographs, memorabilia and other research material.

Television Academy Library
University of Southern California
USC University Park Campus
Los Angeles, CA 90089
(213) 740-7311
www.emmys.com/foundation/usclibrary.php

The Academy of Motion Picture Arts and Sciences has an extensive and well-appointed library containing over 27,000 books, 60,000 screenplays and 7 million photographs, along with other ephemera pertaining to the history of motion pictures.

Margaret Herrick Library
Academy of Motion Picture Arts and Sciences
333 South La Cienega Boulevard
Beverly Hills, CA 90211
(310) 247-3020
www.oscars.org/mhl/

You might also consider enrolling in one of the many first-rate film schools across the country. Film school is a place for you to learn, practice and network. Peterson's has a complete guide to film schools. You can find them online: www.petersons.com

FILM FESTIVALS

There are thousands of film festivals all over the world. More often than not, the creative teams behind the films attend these festivals and talk about their work. If you can find the means to actually make and enter a short film in a film festival or two, you have the added potential of finding a distributor and hitting the jackpot.

CONFERENCES AND SEMINARS

The Directors Guild, The Writers Guild and the Academy of Television Arts and Sciences all offer seminars and workshops where you can meet the Hollywood power elite. Go to the organization's Web site to find specific information.

INTERNSHIPS

I've had at least three interns through the Academy of Television Arts and Sciences who have worked with a show I was running. These interns worked for very little money, but they were able to get to know the industry from the inside out. And they were able to make connections with people who were very helpful in their careers. The Directors Guild also has an internship program, as does the American Film Institute.

Know Your Story

You're going to pitch your story in its shortest possible form, making certain you've left enough in for it to make sense. But you're going to know your story inside and out. Give yourself the most complete outline you can so that if there are any holes, you've filled them. Here are some resources to help you learn to structure your script.

BOOKS

The Writer's Journey: Mythic Structure for Writers
by Christopher Vogler
(Published by Michael Wiese Productions; October, 1998)

Write Screenplays that Sell: The Ackerman Way
by Hal Ackerman
(Published by Tallfellow Press; October, 2003)

How to Write a Movie in 21 Days
by Viki King
(Published by Harper Resource; December, 1993)

Story: Substance, Structure, Style and the Principles of Screenwriting
by Robert McKee
(Published by Regan Books; December, 1997)

WORKSHOPS AND SUPPORT GROUPS

John Truby does the best analysis of story I've ever heard. He teaches live, two-day seminars all over the country. You can call his office or check his Web site to see if he's coming to a city near you.

Additionally, John offers online classes, audio classes and software for building story structure. Purchasing any of his resource material is an excellent investment in your own career.

John Truby Seminars
664 Brooktree Road
Santa Monica, CA 90402
(800) 338-7829
www.truby.com

This month-long intensive workshop has had phenomenal success in jump-starting careers. Your commitment to them is one weekend and then five weeknights spread out over five weeks. It will challenge you in every way. If you're ready to take on the Industry, you're ready for Flash Forward.
Flash Forward
flashforwardinstitute.com

This is a six-week intensive workshop to get your script in terrific shape.

Writers Boot Camp
2525 Michigan Avenue, Bldg. 1
Bergamot Station Arts Center
Santa Monica, CA 90404
(800) 800-1733
info@writersbootcamp.com

Know Yourself

I've saved the most difficult for last.

You can't write powerful material unless you're willing to look at yourself, warts and all, talents and all. I don't believe that you have to be self-denigrating to reach enlightenment. You need to know exactly who you are, no better and no worse. You need to write what resonates with you and what brings you as close to personal truth as possible.

Abbott's Third Law of the Unpredictable Universe: the more specific and personal you get with your writing, the more universal will be its appeal. Don't try to guess what other people will want to see; write what has meaning to you and it will have meaning to others.

In the meantime, while you're waiting for the world to acknowledge your writing gift, don't forget to keep learning, keep exploring, keep asking questions, keep looking under every rock. Don't spend all your time analyzing the industry and talking about television and movies. Real movies are based on real life, not on other movies. Find time to be of service to others because writing and selling scripts can become a very selfish, self-occupied business. Looking outside yourself will make you a better person and as a by-product, you'll have better things to write about.

Don't forget to eat right and exercise. This is a marathon you're about to run, not a sprint. You're going to need all your strength just to survive the business, never mind the writing! And if you can nurture your spiritual self, you'll have something to turn to when your majestic career is over. And you'll be glad.

Find yourself. Find your voice. Find your story. Write it.

Chris Abbott has been writing and producing network television shows for twenty-five years. Starting as a story editor on *Little House on the Prairie*, she quickly rose from executive story consultant on *Cagney and Lacey* to co-producer, producer and finally supervising producer on *Magnum, P.I.* While on *Magnum*, she also wrote episodes for such iconic guest stars as Carol Burnett and Frank Sinatra.

Partnered with Tom Selleck and Chas. Floyd Johnson in Banana Road Productions, Chris wrote and produced *Revealing Evidence* for NBC, starring Stanley Tucci and Mary Page Keller, and *Silver Fox* for ABC, starring James Coburn. She also wrote and produced twelve two-hour movies for the ABC Mystery Wheel, starring Burt Reynolds.

For her own company, she has written and executive-produced *Doctor Quinn Medicine Woman* and *Diagnosis Murder*. She also created and executive-produced the *Legacy* series for UPN.

Chris has lectured and conducted writing workshops at UCLA, Loyola Marymount and the University of North Carolina. She currently lives with her husband and son in St. George, Utah, where she is painting, sculpting and working on a novel.